for
# Strength
and
# Stamina

Seema Sondhi

wisdom
tree

*Published by*

Wisdom Tree
4779/23, Ansari Road
Darya Ganj, New Delhi-110002
*Ph.* 23247966/67/68

*Printed at*

Print Perfect
New Delhi-110 064

# Contents

# 1

# About Yoga

If you are a beginner and are considering taking up yoga to stay strong and healthy through your life, it is important for you to understand what yoga is.

Yoga is a complete science of life that originated in India thousands of years ago. It is the oldest system of personal development in the world, encompassing the body, mind and spirit. The beauty of yoga is that anyone can practice it. There is no need for special clothes or equipment. All we need is a small space and a strong desire for a healthier and fulfilling life.

The word 'yoga' means 'union', and its aim is the unity of our entire being. Yoga teaches us to lead our lives with awareness. It is about being in the present moment for the right thought and right action. Yoga is also described as an inward journey, unveiling the layers of the mind and body. It introduces us to our true self. A person's true self is his true nature, a nature that is pure and clear. Such a nature is termed *sat-chit-ananda* by yogis. The word *sat* means 'real', *chit* means 'awareness or consciousness', and the word *ananda* means 'bliss'. The self that we are made up of is never incomplete or in disharmony.

However, living in this world makes us lose ourselves and forget what we are capable of. Yoga is the only way to re-introduce us to our true selves. It is the only way to reconnect.

The most common mistake people make is that they relate yoga to the physical aspect. However, yoga is far beyond the physical level. People identify themselves with their bodies; they are more aware of what is going on at the physical level than what is going on in their minds. The yogis were aware of this and thus devised a solution to reach the mind or the inner being. As people connect easily with the body, yoga teaches us to move towards the bodily sensations first. After this is achieved, yoga moves us into the realms of the mind by helping us to identify the sensations of the body with the thoughts of the mind. Thus, we reach our mind, get to know ourselves and reach a state of harmony with our true self.

There are five basic principles of yoga that can be incorporated into our own pattern of living to provide a foundation for a long and healthy life led with courage, strength and conviction. Here we will incorporate the four principles that are a must to gain strength, stamina and flexibility of the mind and the body. The yoga *asanas* are excellent cardiovascular exercises that help in developing the core strength of the body. *Pranayama*, that is, 'correct breathing', improves the intake of oxygen and helps to release toxins that cause stiffness in the body and dullness of the mind. Breathing is the way to the mind — one learns to control the mind through control of one's breath. Relaxation is a must in any form of exercise and also in daily life. After exercise, relaxation relieves the tension from all the muscles and

rejuvenates the mind and the body, leaving us feeling refreshed, energised and positive. With yoga, the three factors: the body, the mind and the breath are maintained in a state of harmony. It is the union of the body, mind and breath through *asanas*, *pranayama* and relaxation, creating sublime bliss.

The fourth principle is diet. Diet is the energy put into the body in the form of food. It should make the body feel light and supple and at the same time help keep the mind calm. Moreover, our diet should be in tune with the needs of the body. The right diet goes a long way in shaping the mind and the body. By following this, we slowly learn to incorporate positive thinking and meditation in our life, removing all negative thoughts and actions. Further, it helps to still the mind, enabling it to reach *sat-chit-ananda*, which is our ultimate aim.

# What are We Made of?

Yoga is the means to achieve a state of harmony with our true being and with Nature. The journey is undertaken to bring about a union between the mind and the body, thus attaining bliss. However, before moving forward on this journey, we need to understand the direction in which we ought to move. That is, we need to understand what yoga implies by union and harmony of the mind and body, i.e. what yoga implies by nature.

Nature, or *prakriti,* comprises of three forces that are called *gunas.* These are also called the forces of Nature and these exist in a state of equilibrium. The three forces or *gunas* are a part of all that exists in our mind and body. That is, once the energy within us takes a form, it is reflected in terms of one of these three forces. Within each one of us, one of the three *gunas* is superior in strength and is manifested in all that we do and in the way we think, with the three forces shaping our personalities. However, we have to work on doing away with one dominating force and in its place bringing about a state of balance. In doing so, we use the *gunas* as a navigating force. Through yoga we recognise which of these three forces is predominant within us, thus making it easier to bring about a state of balance.

# 3

# The Three Forces

*Tamas*: People within this category are dull, gloomy and lazy. They tend to be unconscious about the needs of others and are very greedy. The Sanskrit word *tamas* means blackness and darkness. This signifies the dark energy within the *tamasic* people.

*Rajas*: People within this category are passionate, frenetic and creative, with tremendous amounts of energy. They are fuelled with competition and ambition, are full of desires and strive for all kinds of worldly pleasures. In Sanskrit, *rajas* means impure.

*Sattva*: People within this category are calm, balanced and peaceful, possessing clean energy. They are unselfish, compassionate, focused individuals. *Sattva* in Sanskrit implies pure and perfect.

Let us examine the nature of an individual. A single person is sometimes full of energy and at other times, a victim of dullness. And there are times when this very person is calm and focused. Often, people don't understand how their energies or feelings can change so drastically. The answer to this is simple: a particular human being can have the presence of all the three *gunas* at one time. And the shift in energy is due to the interplay of the three forces.

Humans, by nature, are *sattvic*. A newborn baby is relaxed as he or she is neither touched by vices of greed nor selfishness. But as the baby begins the journey of life, he or she moves away from *prakriti*, that is away from what Nature intends him or her to be. Moreover, our conscience constantly reminds us that the simple, eternal joys of life can be enjoyed only when we are in a state of *sattva*. The bliss in this state and the need for the same has to be understood and accepted before striving to achieve it.

Once accepted, and if there is a desire to change from the existent predominant force, one can move towards the desired direction against all obstacles. The first step is to move from the *tamasic* to the *rajasvic*, i.e. use the energy within to do away with attitude of greed and inertia. This is achieved through the *rajasvic* qualities of ambition and drive towards attainment of all the pleasures the world has to offer. Next is the important change from the *rajasvic* to *sattvic*. The energy of competition has to give way to selfless action, calmness and actions that create love in our hearts. This entire process of change can be easily attained through the regular practice of yoga and its techniques.

Thus, the path to reach the state of *satchitananda* and the different aspects of one's personality have also been defined. Our actions and thoughts are shaped by our personalities. Positive thoughts and actions are gained through the strength of one's personality. Yoga acts through the body to reach the mind; yoga ensures that we work on removing all negative aspects of our personalities so as to reach our true nature. And in doing so, the body gains strength and flexibility and so does the mind. Now let us turn to how this is achieved.

**4**

# Strength and Flexibility through Yoga

The journey through life is characterised by impediments. And life is nothing but learning to cope with these barriers in a positive manner before finally emerging victorious. Each person has his own way of dealing with obstacles depending on his mental, emotional and physical make-up. As in life, so in his *Yoga Sutra,* Patanjali clearly enumerates the many obstacles in the yogic path. These obstacles are called *kleshas*, namely, *avidya* – ignorance, *asmita* – ego, *raga* – attachment to pleasure, *dvesha* – aversion to pain and *abhinivesha* – fear. The sage also explains the nine minor obstacles one faces from time to time. These are illness, listlessness, doubt, carelessness, laziness, craving, delusion, and the inability to progress and to maintain progress. The regular practice of yoga –- *asanas*, *pranayama* and relaxation techniques — teaches us to deal with these obstacles and overcome them.

Depending upon our nature and the type of goals we have set for ourselves, we will experience obstacles during our yoga practice. This

9

is essential for us to bear in mind before embarking on the yogic path. Various hurdles will distract the mind and pull us away from our goals. But by staying focused and by being serious about our practice, we can reach our desired goal. By creating awareness, yoga focuses on our consciousness of the present. Through yoga, we learn the art of control over our mind and body. With regular practice, the mind will gradually lose its rigidity and become responsive to change. The problems that seemed insurmountable will no longer appear daunting. The difference lies in the way we think and act when confronted with hurdles. And, the body in its turn will stretch accordingly, to acquire flexibility.

It is important to note that flexibility is not a product of our effort, so we should not rush to try to become flexible in a matter of days. The more we try, the more we will fail. The way to flexibility is the way to know the self. The key to the game is *surrender*. Surrender the ego and let Nature take its course. Release all the emotional build up in your mind and work on changing the way you think. Let go of all your thoughts and work on making your mind peaceful and silent.

Flexibility is a by-product of stretching. But when approached with a competitive and egoistic attitude, it becomes an act of violence. This competitive attitude causes injury to the body. Know yourself, know your body. Don't set targets beyond your body's capacity. Competition, ego and over-reaching goals cause frustration, leading to negativity. Negativity in the mind will cause the muscles to tighten; we will also lose our energy and end up feeling completely exhausted.

Instead, work on opening up the body gradually. Progressive opening up of the body and releasing tension from the muscles comes

with time. Visualise the stretch or the pose that you intend to perform in the mind and then concentrate on the group of muscles that are involved in the stretch. This will help the mind to understand the stretch. Move into the posture and bring your attention to the area or the muscle involved. Release the tension in the muscle slowly. Relax the body and observe the body and the breath.

Approached in this way, yoga practice will make us sensitive to our inner self. We will become aware of the body and also of the mind, the feelings and the emotions. The more we get in touch with our true self and work on changes from within, the greater the strength and flexibility that will be created in the body. As we progress in our practice with awareness, we will begin to feel better about our own self and everything in life will change for the better too. This change is not due to the absence of pains and sorrows. Life and its ups and downs will continue. But as an individual, there will be a change in the way we think and react. Every thought will be more positive, giving us the courage to withstand difficulties. This is because when this journey of self-discovery begins, the energy created makes all things possible. The barriers appear to be nothing but stepping-stones on the path to victory.

# 5

# Creating Love through Yoga

The above-mentioned discussion repeatedly emphasises on yoga being more than just the association with the physical body. Gaining strength and flexibility of the body comes as a byproduct of gaining strength and flexibility of the mind. It has also been stated before that we are generally more aware of our physical body than the state of our mind. A related issue is discontentment over our physical appearance.

The society that we live in has taught us to dislike the way we look. Most of us have created a negative image of our own self. Women are dissatisfied with the thighs and hips, while men are dissatisfied with the abdomen — the areas each gender tends to gain weight most easily. But why do most people hold negative images of their own bodies? The reason is that we are a weight-obsessed society with excessively high standards. This causes insecurity, not only in the people who are fat, but also in people who don't have a well- proportioned body. The regular practice of yoga helps to replace this negative image with a positive one. It teaches us to accept and love ourselves the way we are.

Another cause for concern is our competitive spirit. It is a part of our culture wherein we are driven to excel in our fields. Often this leads

to defeat, as no single person is good at everything. This in turn generates negativity. For most of us, a negative body image grows from repeated comparison with idealised role models. Regular yoga practice reduces the tendency to compete, thereby doing away with another source of negativity.

*Hatha yoga* tackles the problem of pessimism towards one's own self in a gradual yet effective manner over time. However, the golden rule to remember here is that when we are on our yoga mat, we should be our true self. There should be no pretensions. Know that this is the time you give to yourself. There is no one to please and no one to compete with except your former self. In this manner, you will learn to experience the body the way it is and to work within the body's limits at that particular moment. This will make you understand and know your body at a more intimate level. You will know what makes you feel good and what doesn't, where the muscles hold tension, where the muscles are flexible, how you balance, how the breath moves in the body, how the mind reacts to the body and what the demands of the postures are. By developing a deep-rooted relationship with our body, yoga will teach us to appreciate the pleasures that come with strength, stamina, balance and conscious breathing. This reduces the competitive nature and increases self-esteem and confidence.

Thus by replacing negative thoughts with positive ones, yoga replaces self-judgment and shame with true appreciation and pleasure. Yoga teaches us to love our body.

# Understanding Stretching and Flexibility

Yoga teaches us to gain strength of character and this comes simultaneously with a strong and flexible body. However, we need to understand the intricacies involved in stretching in order to gain flexibility. Those who do not practice *hatha yoga* regularly know nothing about stretching and flexibility. These are the people who find the simplest of postures difficult to perform initially as their body is stiff. Basically, such people fail to understand the working of the muscles in their body; here is thus provided an insight into its internal working pattern.

## Muscles

Our body is made up of a group of muscles that help our limbs to move through a range of motions. They act in the following cooperating groups:

*Agonist*: These muscles are responsible for generating movement in the joints.

*Antagonist*: As the name suggests, the work done by these muscles is in opposition to the movements generated by the agonists. These help in returning the joint to its original position.

*Synergists*: These muscles help in naturalising the extra motion generated by the agonists to make sure that the force generated is within the required plane of motion.

*Fixators*: These muscles provide the necessary support to hold the rest of the body in equilibrium while in motion and stabilise the muscles.

Soft tissues bound the muscles on all sides. These tissues are called *connective tissues*. When the body is inflexible, it shows that the connective tissues are stiffer than the muscles. These tissues are composed of two important protein-based fibres, called *collagenous* and *elastic* connective tissues. The collagenous tissues are mostly made of collagen. They provide strength and maintain the stiffness. The elastic tissues provide the elasticity as these are mostly made up of elastin that helps in increasing flexibility when stretched in a proper way. Inactivity in the body causes the muscles and joints to become stiff. However, exercising and doing the yoga postures can cause the muscles and joints to undergo chemical changes around the tissues that are stiff, thus releasing toxins and consequently increasing the flexibility of that particular muscle and joint.

# Nerves

The entire muscular and skeletal system is made up of peripheral nerve endings. These nerves link the muscular-skeletal system to the nervous system; these are called the proprioceptors. These proprioceptors are very sensitive to stretch but in no way do they restrict the movement of the muscles. Instead, they act as sensors. These sensors help to protect us against injury by governing our range of motions in active movement. Any attempt to move the body beyond the set limit sends a signal to the nervous system and the muscles completely shut down, thus protecting us from any potential injury.

# Kinds of Stretching and Flexibility

There can be many kinds of flexibility. The different kinds are grouped according to the different types of activities that we choose to perform.

*Dynamic flexibility* is the ability to perform dynamic movements of the muscles. It involves controlled leg and arm swings that take us gently to the limits of the body's range of motion.

*Ballistic flexibility* involves a lot of bouncing and is considered dangerous because it forces the muscles to act beyond their range of motion. This can even lead to injury and a good example of this is all the aerobic activities.

*Static active flexibility* is the ability of the muscles to assume and maintain the extended position, using only the tension of the muscles. These stretches can be held for 10 to 20 seconds.

*Passive static flexibility* is to assume the positions of the stretch and then maintain them using only the body weight. Often such stretching

is called *relaxed stretching* as it helps in releasing all the spasms from the muscles. All yoga postures are a good example of this stretch.

All the above-mentioned information gives us an understanding of stretching and flexibility. Let us now start the journey towards a body and mind that is strong and flexible.

# 8

# Preparing to Stretch

Before beginning the daily stretching routine, we must learn to create the right conditions. Always begin with a good warm-up routine as it increases the cardiovascular output. An increase in the body's core temperature allows the blood to flow freely in the muscles, thereby improving their flexibility. Right clothing, equipment and the type of place where we do our stretching are also very important. Flexibility is easier when the area is warm. Similarly, the time of the day also influences flexibility. Early morning the body is stiff due to inactivity, inhibiting flexibility. Also remember that if you are recovering from any injury, take the time to heal the body first. Only then embark on the regular routine of stretching.

Visualise in the mind the stretch or the pose that you intend to perform, and then concentrate on the group of muscles that you will use, as it will help the mind to understand the stretch. Move into the posture and bring your attention to the area or the type of muscle in use in the body, relax and observe the body and the breath.

Finally, the type of muscles and the joints that you work on are

important factors for consideration. Bear in mind that certain joints are not meant to be flexible. Also, we must note that women by nature are more flexible than men.

# 9

# Asanas

Yogic techniques are an excellent way to stretch the body and to gain strength and stamina. The practice of yoga involves both the body and the mind. Daily practice involves will power and perseverance. The reward for perseverance is worth all the dedication put into it. Regular practice of yoga exercises can improve our health, increase our resistance and develop mental awareness. Other exercise regimes tend to trap lactic acid in the tight muscles, leading to accumulation of waste products in the muscles during these exercise sessions. On the other hand, yogic stretching helps release lactic acid from the muscles into the bloodstream so that it does not hinder muscle contraction.

The *asanas* work on all parts of the body. They make the spine and joints supple and tone the muscles, glands and internal organs. Though the *asanas* may seem to be mere physical exercises, we will later realise that they are much more than that. As and when we progress, we will become aware of the flow of *prana*, the vital energy in our body. We also become aware of the importance of correct breathing, i.e. creating a

union between our breath and our movement. So let us begin this amazing journey towards making our body and mind strong and flexible.

# Surya Namaskar (Sun Salutation)

*Surya namaskar* is the best yogic exercise as both the benefits of *asana* and *pranayama* can be attained in this series of 12 postures. The sun salutation makes the entire body flexible and prepares the body for the other *asanas*. It tones, stretches and massages all the joints, muscles and internal organs. It also helps to regulate our breathing and focus our mind. It recharges the solar plexus and stimulates the cardio-vascular system. While practicing the sun salutation, turn inwards and become aware of each moment, especially as you near the end of the round when fatigue can lead to sloppiness.

Begin by standing straight up, legs and feet joined together, arms by the side. Relax the shoulders, pull the stomach in and expand the chest. This is the proper upright position. Close your eyes and become aware of your body. Begin to relax your body mentally.

- Exhale. Join your palms together in a *namaskar* position in front of your chest and mentally direct the awareness inward towards the heart centre.

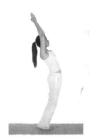

- Inhale. Stretch your arms straight over the head, arching the body backwards. Knees and elbows should be straight with your arms kept on either side of your ears.

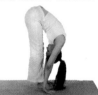

- Exhale. Slowly bend forward, bringing your hands to the floor, next to your feet. Try to touch your forehead to your knees, keeping your knees straight. If your hands fail to reach the floor, bend the knees. Do not strain yourself.

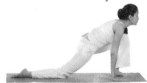

- Inhale. Without moving your hands, look up and stretch your right leg backwards as far as possible. Placing your right knee on the floor, stretch your head upwards. Keep the left knee at right angle, directly over the ankle.

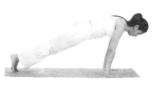

- Retain the breath. Move your left foot in position, beside your right foot. At the same time, lift your hips and lower your head between your arms so that your back and legs form a perfect triangle. Push your heels towards the floor. Your palms should be flat on the floor.

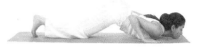

- Exhale. Dip your knees, chest and chin or forehead to the floor, lifting your hips and abdomen up. If this is difficult initially, then lower your knees first, followed by your chest and finally your chin and then move your hips up.

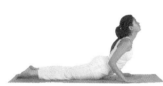

- Inhale. Slide your body forward till your hips are on the floor. Arch your back and chest upwards and drop your head back. Your legs, hips and hands remain on the floor.

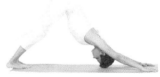

- Exhale. Tuck in your toes and without moving your hands and feet, lift your hips as high up as possible and lower your head between your arms so that your body forms a triangle.

27

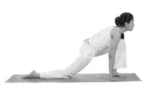

- Inhale. Bring your right foot forward between your hands so that your fingers and toes are lined up together. Move your left leg back with knees touching the floor. Stretch your head upwards.

- Exhale. Without moving your hands, bring your left leg forward, next to the right foot, hands close to your feet and forehead on your knees (*position 3*).

- Inhale. Stretch your body up and arch backwards (*position 2*).

- Exhale. Bring both the palms together in the *namaskar* posture. Now relax.

These 12 postures are practiced twice to complete one round of *surya namaskar* with the right and left legs alternating, by coming forward and moving backwards. Try and do six to eight rounds of *surya namaskar* and then increase to 10 rounds.

# THE STANDING OR BALANCING POSTURES

The legs are the roots of the body. A strong foundation or base is a must to develop a strong and flexible body overall. The balancing postures help in developing the brain centre that controls the function of the movements made and work towards creating physical and mental balance. These postures are important in the beginning as these help in creating balance and awareness; however, these will be difficult to perform, as they require focus and steadiness. Regular practice will enable you to overcome this minor difficulty.

While practicing these postures, the stumbling blocks you might encounter are stiff and inflexible muscles and tight hamstrings. Tight hamstrings are a big challenge to anyone practicing yoga. The three hamstrings originate from the sitting bone; they run down the back of the leg to attach to the lower leg-bone muscle. The key to loosening the hamstrings is a regular stretching and strengthening routine that involves not only the hamstrings, but also the surrounding group of muscles, the glutes (buttocks), lower back and the quadriceps.

The standing postures impart strength to the knees, thighs, ankles and hips. This implies strengthening of the lower half of the body, achieved through lengthening of the upper body. This will energise your body, make you feel more grounded and improve the body posture. Regular practice helps to increase the strength and stamina of the spine and to increase the overall strength of the legs, knees and shoulder muscles.

# VRIKASANA (TREE POSE)

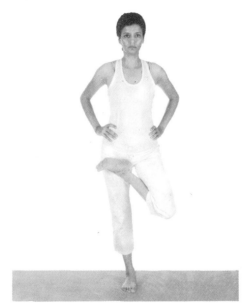

- Stand with feet together, arms by the side and head straight. Fix the gaze on a point at eye level and breathe for a few seconds. Balancing on the right leg, bend the left knee and place the left foot on the root of the right thigh, in the half lotus position. Hold the waist with both hands, balancing in this pose and breathing deeply.

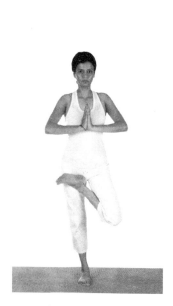

- Release the arms, joining the palms together in the *namaste* position.

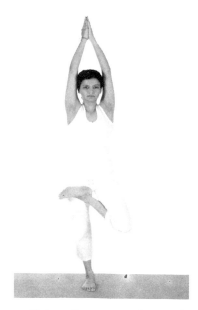

- Raise the arms above the head, keeping the palms together and elbows held straight. Hold the position for 20 seconds, focusing the eyes at a point and the mind on the breath.

# Eka Padasana (One-Foot Pose)

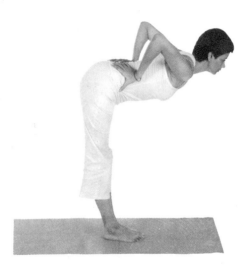

- Stand with feet together, arms by the side and head held straight. Fix the gaze on a point at eye level and breathe for a few seconds. Inhale, raise the arms and support the spine with both the palms. Exhale, bend forward from the hips, keeping the torso and head in a straight line. Rest in this position by breathing normally.

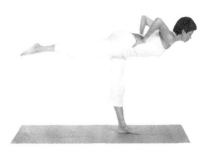

- Exhale, lift the right leg from the floor and stretch it behind by swinging the body slightly forward. Keep the right leg stiff behind and the weight of the body on the left leg, with the left leg kept firmly on the floor. Focus on the breath to hold the position for a few seconds.

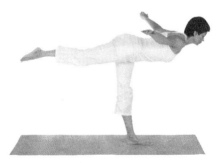

- Inhale, release the arms out to the side, balancing on the left leg. Hold this position for as long as comfortable. Repeat the steps with the left leg.

33

# Natarajasana (Lord Shiva's Pose)

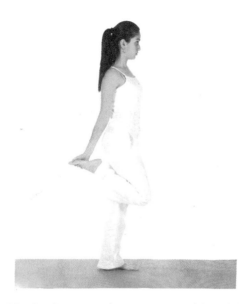

- Stand with the feet together, spine and head held straight and arms by the side, close to the body. Focus the gaze at a fixed point at eye level and relax the body, breathing normally. Bend the right knee and hold the ankle with the right hand behind the body. Keep both the knees together and maintain the balance.

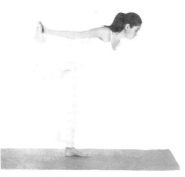

- Inhale. Slowly stretch the right leg backwards, raising the leg behind the body.

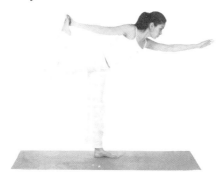

- Exhale. Raise the left arm upward and forward. Hold the posture for as long as possible, breathing normally. Release the posture by bringing the leg and arm down. Repeat the same steps with the left leg.

# Virabhadrasana (Warrior Pose-1)

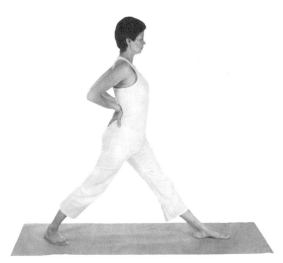

- Separate the legs 3 or 3.5 feet apart, spin the torso to the left and open the left foot outward by 90 degrees and the right foot inward to about 60 degrees. Inhale. Elongate the spine, supporting the spine with both the arms. Exhale, bend the left knee to a 90-degree angle to bring the left thigh parallel to the floor, keeping the knee directly over the heel. Stay balanced in this position keeping the shoulder over the hips, reaching firmly through a long, straight back leg.

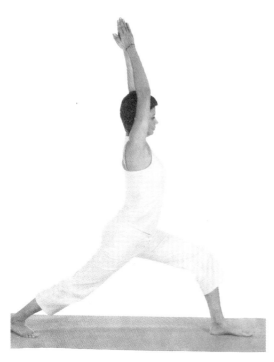

- Inhale. Extend the arms out to the sides and then up over the head with palms together. Hold this position, breathing deeply. Release the posture by bringing the arms down. Straighten the knees. Repeat the same steps with the right leg.

37

# Virabhadrasana (Warrior Pose-2)

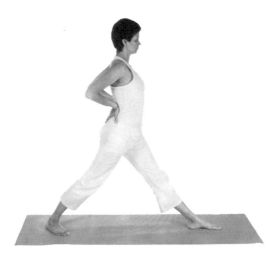

- Stand with your feet together, head held straight. Take a big step backward with the right foot, place the hands on your hips and square the pelvis. Hold this position, breathing deeply. Exhale. Bend the left knee to a 90-degree angle to bring the left thigh parallel to the floor, keeping the knee directly over the heels. Drop the right knee down on the floor and stretch the leg behind. Press the right leg firmly into the floor while rising upwards through the abdomen, spine and shoulders. Place the palms on the left thigh gently, fixing the gaze at a fixed point.

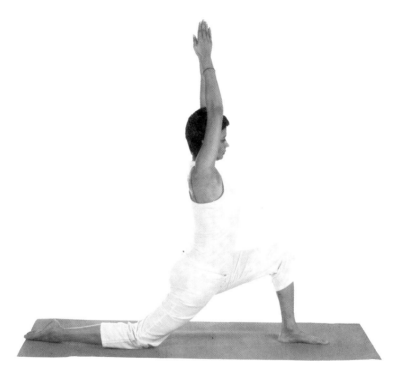

- Raise the arms up, palms parallel to each other. Hold this position and widen the stance to prevent the left knee from slipping in front of the ankle. Release the posture and repeat on the other side.

# Parsvottanasana (Side Chest Stretch)

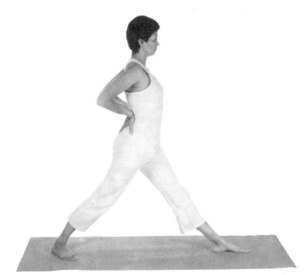

- Stand with your feet together, head held straight. Take a big step backward with the right foot, place the hands on your hips and square the pelvis. Hold this position while breathing deeply. Inhale. Extend the arms out to the sides and then up over your head with the hands shoulder-distance apart and palms facing each other. Exhale. Extend the spine forward, arms held parallel to each other.

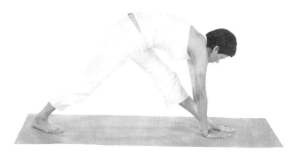

- Place the palms on the floor by the side of the left foot. Hold this position for a few breaths.

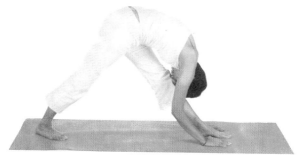

- Exhale and touch the forehead to the left knee. Hold this position for 20 seconds, breathing deeply. Inhale. Look up and raise the hands up, lift the spine up, drop the hands by the sides, lift the right foot and stand with both feet together. Repeat the same, this time by taking the left leg backwards.

41

# Parsvakonasana (Extended Side-angle Pose)

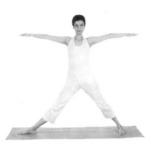

- Separate the legs 4 to 4.4 feet apart. Turn the right foot 90 degrees to the right, and left foot slightly to the right, keeping the left foot out and stretched at the knee. Raise the arms out to the side, in line with the shoulders and palms facing down.

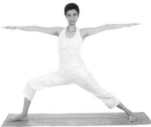

- Exhale. Bend the right leg from the knee until the thigh and the calf muscle form a right angle and the right thigh is parallel to the floor. Hold this position for a few breaths.

42

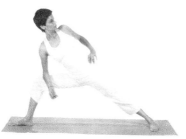

- Exhale. Place the right elbow on the right thigh, the left arm on the left hipbone, and look towards the left shoulder.

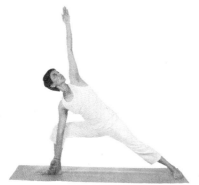

- Inhale. Stretch the left hand up with the palm facing out. Exhale. Place the right palm on the floor, close to the right foot. Look towards the left hand and hold the position for 20 seconds. Repeat the same on the left leg.

# Prasarita Padattanasana (Wide-angle Standing Forward Bend)

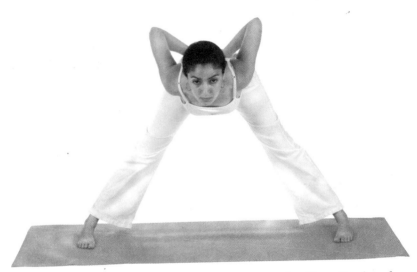

- Separate the legs 4 to 4.4 feet apart. Inhale. Place the hands on the waist and tighten the legs by drawing the kneecaps up. Exhale. Extend the spine forward and hold this position for a few breaths.

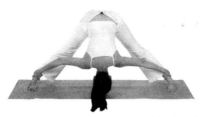

- Exhale. Extend the spine forward and hold the right toe or ankle with the right hand, left toe or ankle with the left hand. Try to touch the crown of the head on the floor. Hold this position for 20 to 30 seconds, breathing deeply and evenly.

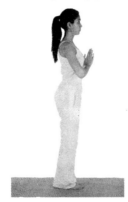

- Inhale. Lift the head from the floor and release the hands. Join the legs and stand with feet together, arms bent in *namaste* position and breathe deeply.

# UTTANASANA (FORWARD STANDING POSE)

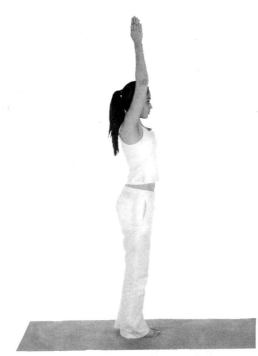

- Stand with your feet together or at hip-distance apart. Inhale. Raise your arms up and above, stretching the body.

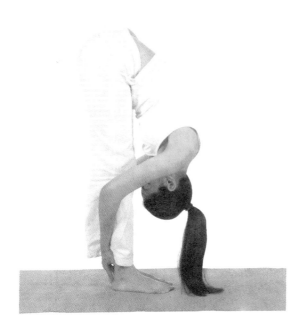

- Exhale. Bend forward from the hips, tighten the kneecaps and press the balls of the ankles on the floor, shifting the weight of the entire body on your feet. Hold the ankles from behind, pressing the elbows on the calf muscles and touch your forehead to the knees. Hold this position for 30 to 60 seconds, breathing deeply and work on extending the spine. Inhale. Raise the arms and release the posture.

# SITTING FORWARD BENDS

The entire sitting forward bends focus on the spine and the abdomen. At the physical level, they lengthen the spine, stretching it from the neck to the sacrum. Stretch the shoulder girdle muscles and the back of the legs, improving blood circulation in the legs. Internally, these postures massage the abdominal organs, improve digestion and eliminate and tone the reproductive organs and the kidneys. Thus, these postures focus on opening the blocked areas along the spine, pelvis, lower abdomen and legs. At the mental level, these postures are antidotes to anxiety and impatience, and teach the art of surrender.

The key to the sitting forward bends is a straight spine. This means maintaining the natural spinal curve so that the weight of the head and the torso are centred over the pelvis. This is difficult for many due to the stiffness of the legs and hips, with tension in the pelvis. In yoga there are many postures that help to strengthen and make these areas flexible by stretching the muscles of the lower back and the inner thigh. The forward bends help to achieve this by using gravity to release the tension and pain. The end result of these postures is an energised and rejuvenated body.

# Ardh Padmasana (Half-Lotus Cradle)

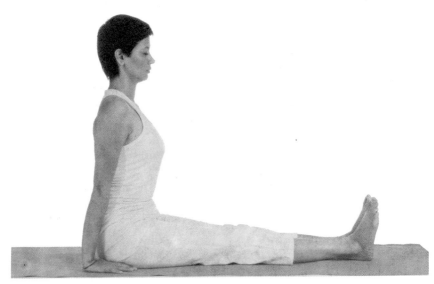

- Sit erect and stretch your legs straight out in the front. Place your palms by the side of the hips, press the fingertips into the floor to help extend the spine — right from the crown of the head and down through the tailbone. Keep the legs active, kneecaps pulled up, heels reaching out and the thigh bone touching down.

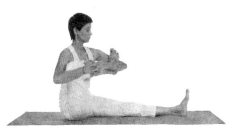

- Bend the right knee out to the side and hold the bottom of the foot with the left hand and the knee with the right hand. Place the sole of the right foot in the crook of the left elbow, and the knee in the right elbow, cradling the lower left leg in the arms.

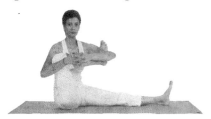

- Keep the spine straight and draw the leg towards the chest, keeping the knee and foot at equal distance from the torso. Hold this position for a few seconds, and then start to rock the leg gently from side to side to soften the hip joint. Bring the thigh closer to the body to open the hip joint. Hold this position for one minute or more, rocking gently. Lower the right leg and repeat the same on the other side.

51

# Ardh Padma Janu Shirshasana (Half-lotus Head to Knee Pose I + II)

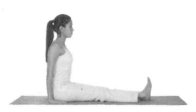

- Sit erect and stretch your legs straight out in the front. Place your palms by the side of the hips, press the fingertips into the floor to help extend the spine from head to bottom. Bend the left knee and bring the left foot on top of the right thigh so that the heel presses into the lower right abdomen. Release the knee towards the floor. Inhale. Lift both the arms up, raising the torso.

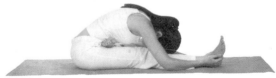

- Exhale. Contract the abdominal muscles, extend the pelvis forward. Keep the pelvis and chest over right leg and hold the outer edges of the right foot with your hands. Extend the torso forward. Hold this position, breathing deeply. If comfortable in this position, move ahead a little further into the second part.

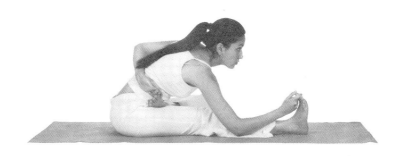

- Lift the torso to roll the left shoulder open and slip the left arm behind the waist to hold the left toe.

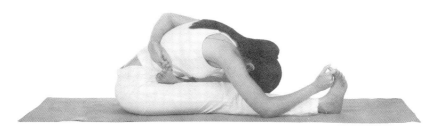

- Extend the spine forward to touch the pelvis, keeping the chest over the right leg. Hold this position for 30 to 60 seconds, breathing deeply and smoothly. Release the arm, and stretch up to lift the torso back to the centre. Gently unfold the left knee and straighten the leg. Repeat the same on the other side.

53

# Upavistha Konasana (Seated Angle Pose on the Wall)

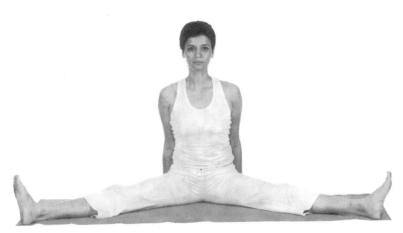

- Separate the feet apart on the floor, keeping the legs straight and the feet at equal distance from the centreline of the torso. Press the hands on the floor, lifting the torso slightly and align the pelvis, spreading the legs a bit further apart. If you are unable to sit straight, that is, if the lower body is rounded and if the lumbar spine has reversed its normal curve, elevate the base of the spine with a cushion.

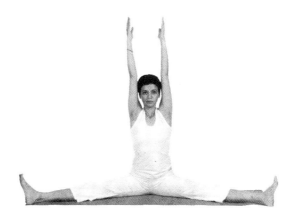

- Inhale. Raise the arms up, keeping them parallel to each other. Keep the knees squeezed and toes flexed in and the ankles pressing towards the floor.

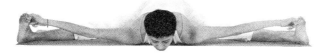

- Exhale. Lengthen the spine and extend it forward, bringing the abdomen and chest towards the floor. Hold the right toe with the right hand and left toe with the left hand. Touch the chin or forehead to the floor. Hold this position for as long as comfortable, breathing deeply. Inhale. Lift the spine up and release the posture.

55

# KROUNCHASANA (LEG STRETCH)

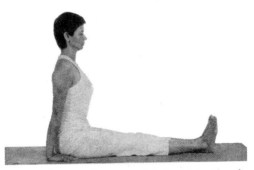

- Sit erect and stretch your legs straight out in the front.

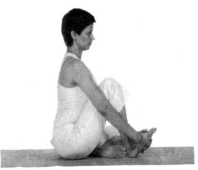

- Bend the right leg from the knee and place the foot close to the hip joint, toes pointing back and placed on the floor.

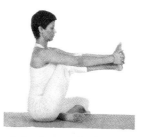

- Exhale. Bend the right knee, hold the right foot with both the hands and slowly raise the leg up. Keeping the thigh against the chest, slowly raise the leg vertically.

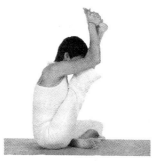

- Fix the gaze on the right toe and stretch the leg out straight and keep the spine straight. Focus on the breath, bring the leg towards the chest and touch the forehead to the knee. Hold this position, breathing deeply for 20 seconds and then release the leg down and repeat the same on the other side.

# Ubhaya Padangusthasana (Both Legs Stretched)

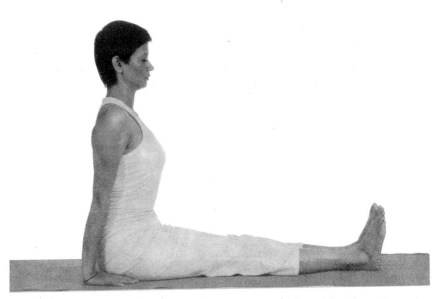

- Sit erect and stretch the legs straight out in the front. Place the palms by the side of the hips.

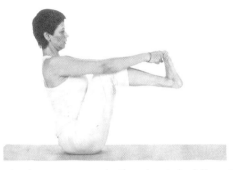

- Bend both the knees towards the chest, holding the toes with the hands. Breathe deeply.

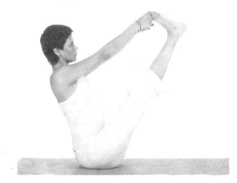

- Inhale. Balancing on the hips, straighten the knees and keep the spine straight. Hold the posture for 20 to 30 seconds, breathing deeply. Release the posture and straighten the legs out.

59

# Pascimottanasana (Forward Bend)

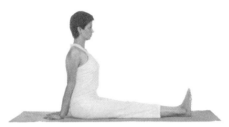

- Sit erect and stretch your legs straight out in front. Place your palms by the side of the hips, press the fingertips into the floor to help extend the spine through the crown of the head and down to the tailbone. Keep the legs active, kneecaps pulled up, heels reaching out and the thighbone touching down.

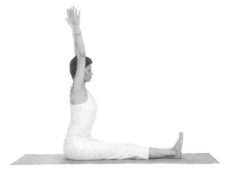

- Inhale; raise both the arms, lifting the torso up.

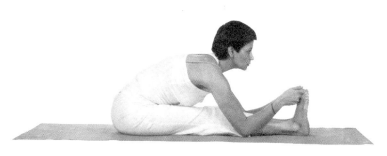

- Exhale. Contract the abdominal muscles, extend the pelvis forward, reaching for the toes. Hold the toes with both the hands and breathe deeply.

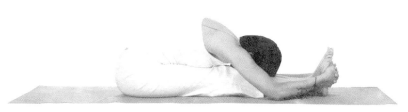

- Exhale. Place the abdomen and chest on the thighs and touch the forehead to the spine bone. Release all tension from and around the shoulders. Hold the position for 30 to 60 seconds, breathing deeply. Inhale. Lift the torso up and release the posture.

# PURVOTTAN ASANA (MOUNTAIN POSE)

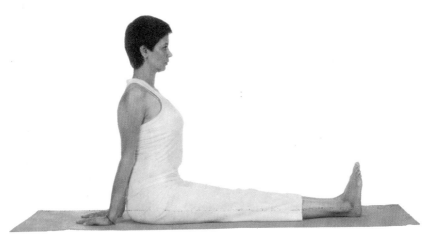

- Sit erect and stretch your legs straight out in front. Place the palms 6 inches behind the hips on the floor, fingers pointing away from the hips, and keep the elbows straight.

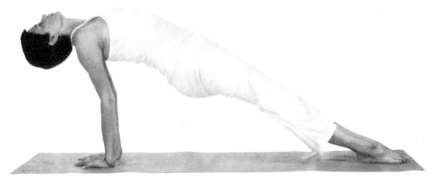

- Inhale. Press the ankles on the floor, and lift the entire body upwards. Contract the hip muscles, expand the chest and drop the neck backwards. Try to keep the soles of the feet flat on the floor. Hold this position for 30 to 60 seconds, breathing deeply. Exhale and lower the body down to release the position.

# Backward Bends

The backward-bend postures expand the chest and facilitate deep inhalation, proving very stimulating and exhilarating. But these postures are difficult, as they require unrestricted movement of many joints in the body, mainly the upper back, lower back, hips and shoulders. At the physical level, these postures stretch the abdominal muscles, spine, shoulders and hips. This in turn greatly influences and benefits the internal organs. These postures are excellent for people with respiratory problems as they expand the rib cage and increase the lung capacity. The backward bends lengthen the spine to create space between the vertebrae, minimising the pressure on the spine and its discs. The backward bends energise the spine, prevent a hunched upper back, relieve backaches, build strength and make the spinal nerves supple. Finally, at the emotional level, these postures teach us to let go of the ego, to release all our fears and to open our arms and accept life the way it is. By helping us to embrace life, these postures open the heart to create love for the self and for others.

While practicing the postures enumerated below, it is essential to bear in mind that the depth of the backward bend is inconsequential. It is more important to distribute the curve evenly along the full length of the spine.

# Sarpasana (Snake Pose)

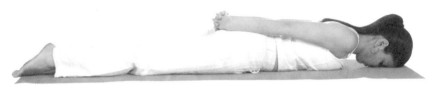

- Lie face down on your abdomen, feet a few inches apart and forehead touching the floor. Stretch the arms backward and interlock the fingers over the hips, palms facing the back of the head and the wrists as far apart as possible.

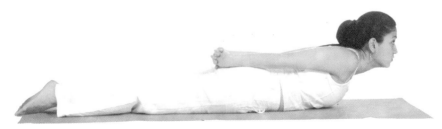

- Inhale. Lift the chest up as far as possible from the floor, raising the upper body backwards into an arch.

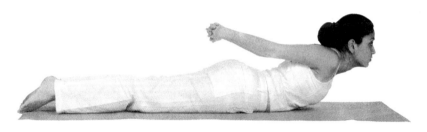

- Draw the shoulders back, pulling the shoulder blades together and raise the arms as high as possible. Keep the back of the neck stretched by looking downward. Hold the posture for 10 breaths, breathing deeply. Exhale. Lower the body down and relax.

# BHUJANGASANA (COBRA POSE)

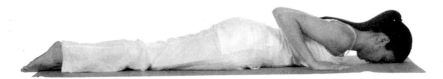

- Lie face down on the abdomen, the feet a few inches apart and the forehead touching the floor. Place the palms close to the chest, fingertips parallel to the shoulders, the shoulders pulled up and elbows parallel to each other.

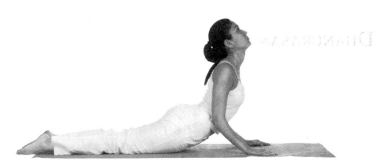

- Inhale. Press your hands into the floor and roll the head up while pulling the spine forward and opening the chest. Straighten the elbows as much as possible. Pull the top of the head up and back while drawing the spine towards the front of the body. Press the shoulder blades down to lift the spine up. Now lift up the chin and drop the head back as far as possible. Hold this position for 20 seconds, breathing deeply.

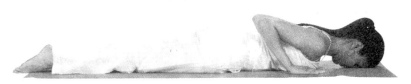

- Exhale. Lower the body down and relax.

# Dhanurasana (Bow Pose)

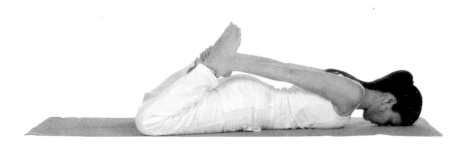

- Lie flat on the abdomen, face down, forehead touching the floor. Keep your arms and hands beside your body and your legs together. Bend your knees, bringing your heels close to your hips. Allow your knees to separate slightly. Hold your right ankle with your right hand and left ankle with your left hand.

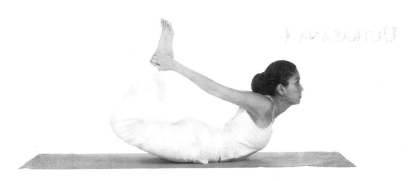

- Inhale. Lift your head and chest off the floor, and simultaneously raise your knees and legs off the floor. Arch your body upwards as much as possible, resting the entire weight of your body on your abdomen (navel centre). Stay in this position for 20 to 30 seconds, breathing normally.

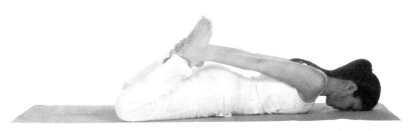

- Slowly bring your head, chest and legs down to release the posture. Repeat two times.

# UUTRASANA (CAMEL POSE)

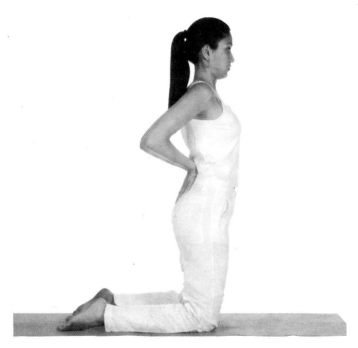

- Kneel on the floor, keep the thighs and feet together, toes pointing back and resting on the floor. The knees can be kept slightly separated, if desired.

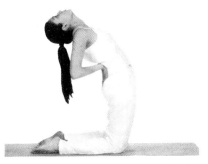

- Support the spine with the palms. Inhale. Lean backwards, pushing the hips and abdomen forward. Expand the chest and shoulders, dropping the neck backwards.

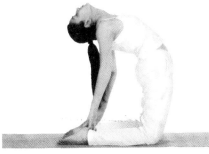

- Exhale. Release the right palm and move down to hold the right ankle and left palm to hold the left ankle. Hold this position for 20 to 30 seconds. Breathe normally. Inhale. Lift up and release the posture.

73

# Urdhva Danurasana (Wheel Pose)

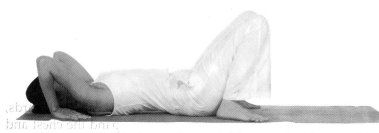

- Lie on the back, knees bent and feet on the floor at hip-width apart. Raise your arms, bend them backwards and place your palms on the floor on either side of the head. The fingers should point towards the feet.

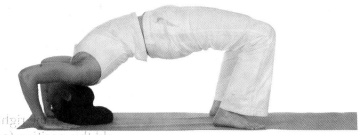

- Lift your hips upward, pressing down on your hands and resting the crown of your head on the floor. Rest briefly, breathing deeply.

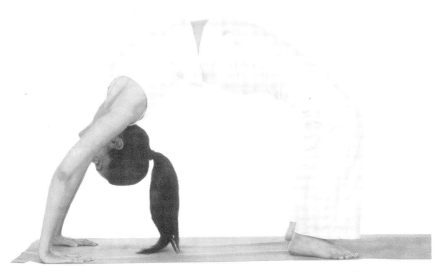

- Inhale. Straighten the arms, making sure that the elbows do not move out to the sides. Raise your body slowly by pressing down into the fingers. Slowly straighten your arms by lifting your head off the ground and raising your hips high. Keep the feet and thighs parallel and the knees directly over the heels. Hold this position for 10 breaths and then lower the body down and relax.

# SHALABASANA (LOCUST POSE)

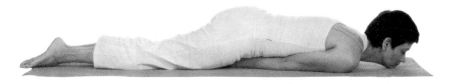

- Lie on the abdomen; clasp the hands together under the body. Bring the elbows close together under the body. Stretch the chin forward and place it on the floor.

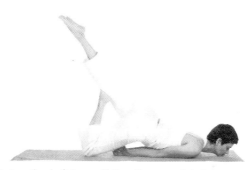

- Inhale. Raise the left leg off the floor, as high as possible, bend the right knee and support the left leg on the right foot. Hold this position for 20 seconds. Exhale, lower the right leg and then the left leg. Repeat the same on the right leg.

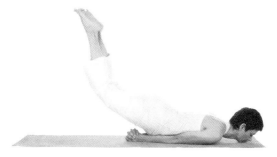

- Inhale. Raise both legs up off the floor as high as possible, pressing the clasped hands on the floor. Hold this position for 10 breaths and then release the posture and relax.

# TWISTED POSTURES

In *hatha yoga*, the forward, the backward and the standing postures train us not to be defeated by gravity. These postures teach us to work with this force in a positive way. However, this is not the case in twisted postures. If we observe our body, we can easily twist the body without any relation to the force of gravity. For instance, we can easily turn the neck from right to left. Twisting postures involve rotation of the spine and involve only the torso. These could be done while standing, sitting, inverted or even lying down. When performing these postures, it is essential to bear in mind that the perfect twist comes from twisting the lower abdominal muscles. This is important as we have a tendency to twist the upper abdomen by squeezing the diaphragm, contracting the rib cage and finally twisting from the neck. Another rule in these postures is to avoid rounding the upper body and to prevent the shoulders from creeping to the ears. Instead, while twisting the lower abdominal muscles, release the shoulder blades down towards the tailbone and extend the breastbone up towards the sky.

Internal twisting postures are a balm for the spine and tight shoulders. These stimulate the spinal nerves and help in making the spine supple and flexible. As these involve twisting of the abdominal muscles, there is a strong influence on the internal organs. The internal organs are toned, thereby soaking them in nutrients and releasing toxins. While practicing these postures, maintain a quiet, receptive attitude. Do not move into the postures in a hurry; instead, move slowly, with patience.

# MARICHYASANA (SAGE TWIST-1)

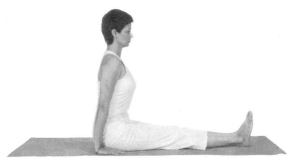

- Sit erect and stretch the legs straight out in front, close to the wall.

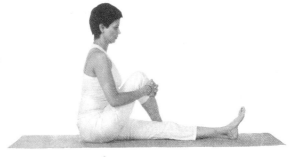

- Bend the right leg and place the heel on the floor, next to outer side of the left knee, interlock the fingers and hold the right knee with both the palms.

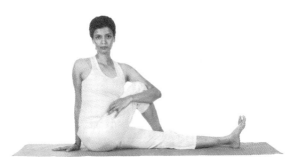

- Inhale. Take the right arm and place the right palm behind, close to the lower spine. Wrap the left hand on the right leg. Hold this position for a few seconds.

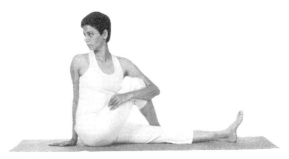

- Exhale. Twist the belly and chest towards the right, to look over the right shoulder. Slowly release the twist, strenghten the legs and repeat on the other side.

81

# ARDH MATYSENDER ASANA (SPINAL TWIST-1)

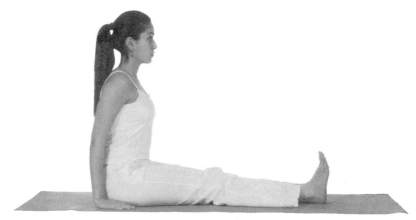

- Sit erect and stretch the legs straight out in front. Place your palms by the side of the hips, press the fingertips into the floor to help extend the spine through the crown of the head and down to the tailbone. Keep the legs active, kneecaps pulled up, heels reaching out and the thighbone touching down. Bend the right leg from the knee and place the right ankle close to the left outer thigh; bend the left knee and place the left ankle close to the right hip. Stretch your right arm up and bring it behind your back. Place the palm on the floor, close to the lower spine to support and keep the spine straight.

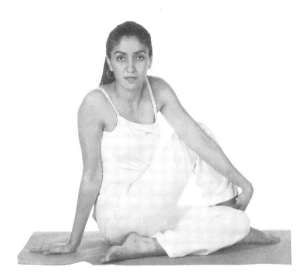

- Stretch your left arm up and bring it over the right side of your right knee. Reach out and hold your right ankle. Look over your right shoulder. Breathe deeply in this position for 20 to 30 seconds. Release the posture and repeat the same sequence on the left side of your body.

# ARDH MATYSENDER ASANA (SPINAL TWIST-2)

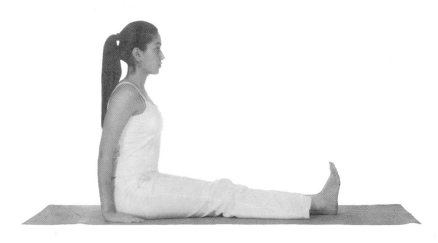

- Sit erect and stretch the legs straight out in front. Place the palms by the side of the hips and press the fingertips into the floor to help extend the spine through the crown of the head and down to the tailbone. Keep the legs active, kneecaps pulled up, heels reaching out and the thighbone touching down.

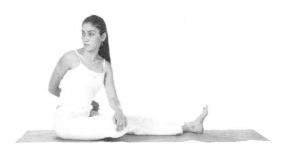

- Bend the right knee and bring the right foot on to the top of the left thigh so that the heel presses into the lower left abdomen. Release the knee towards the floor. Place the left hand on the right knee and twist the body to the right, sweeping the right arm behind to hold the right foot.

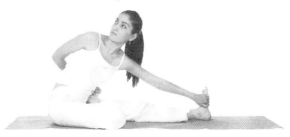

- Look towards the right shoulder, lifting the spine and expanding the chest.Extend the left hand forward to hold left foot. Hold this position for 30 seconds, breathing deeply. Release the twist and repeat on the left side.

85

# Sputa Udarkarkarakarshan Asana (Reclining Twist)

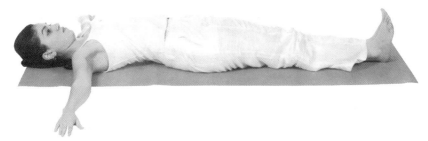

- Lie on your back and stretch the arms directly out to the sides, palms down.

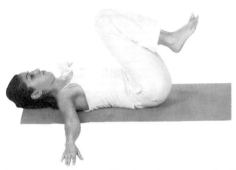

- Bend the knees and bring the thighs towards the abdomen.

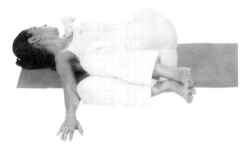

- Exhale. Gently twist from side to side, lowering the legs towards the floor. Keep the upper back and shoulders on the floor and the legs together. Relax the lower back as you twist from side to side, giving a massaging effect to the spine. Repeat this 10 times on each side and then lower the legs on the floor. Straighten the legs and relax.

87

# INVERTED POSTURES

The word 'inverted' means 'to turn upside down' and so it is very clear that in inverted postures, we reverse the action of gravity on the body and the head is lower than the heart. The king of *yoga asanas* is the headstand or *sirsasana* and the queen, the shoulder stand or *sarvangasana*. By reversing the normal effects of gravity, we rest the heart, aid circulation, and relieve pressure on the lower back. Practiced regularly, all the inverted postures prevent back problems and improve memory, concentration, and the sensory faculties. Inverting the body also makes us breathe deeply, bringing a fresh supply of oxygen-rich blood to the brain — any slight breathing difficulty we experience at first will quickly pass. In the headstand, make sure your elbows do not shift out of position. Work on keeping the spine in its natural curvature and the thighs, knees, ankles and the toes stretched and the legs straight. While holding the headstand, never push the body beyond its capacity. In the shoulder stand, do not let the body collapse down on to your foundation, that is mainly the bent elbows and the shoulders. Press down actively through the back of the arms and shoulders and lengthen up through the legs. The use of blankets, which are kept under the neck and shoulders, protects the cervical spine.

Another guideline that applies to the inverted postures is to move into and out of the posture very slowly and with control. Those suffering from heart diseases, recent spinal injuries, inflammation in the eyes and ears, should never practice the inversion. The body needs time to recover (e.g. redistribute the blood) from inverted poses, so give adequate rest after an inversion.

# DOLPHIN

Begin with a set of these *asanas* to prepare the body for the headstand. Practicing this will give strength to the arms and shoulders.

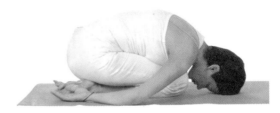

- Kneel on the floor, keep the knees together and sit on the ankles. Rest the forehead on the floor with hands along the sides of the head. Lift to place the forearms on the floor in front. Measure the forearms by holding each elbow with the opposite hand.

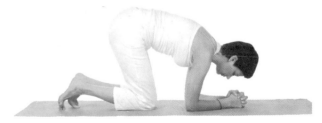

- Bring the hands together to form a tripod on the floor, interlocking the fingers. Curl the toes and bend the knees.

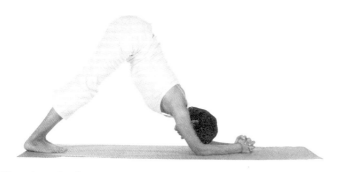

- Keeping the head up, straighten the knees while lifting the hips up towards the sky.

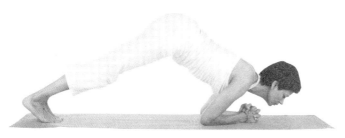

- Inhale. Rock the body forward, keeping the chin in front of the hands. Exhale. Push the body as far back as possible. Try to do two rounds of eight to 10 rocks and then relax.

# CHATURANGA DANDASANA (PLANK POSE)

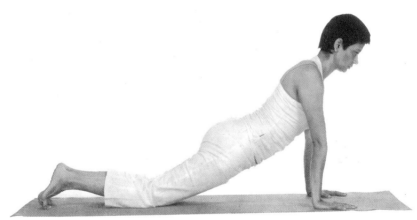

- This posture is a straight continuation from the previous posture. Bend the knees on the floor, curl the toes and place the palms underneath the shoulders. Hold this position for a few seconds, breathing deeply.

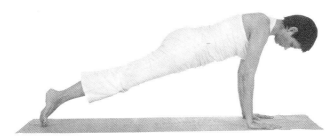

- Inhale. Lift the knees off ther floor, lifting the body up on all the fours, i.e. the curled toes and the palms. Make sure the hands are open and firmly placed on the floor. Draw the awareness up towards the spine and contract the inner thigh muscles, the hips and the abdominal muscles.

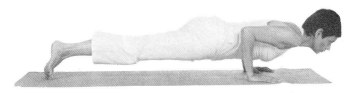

- Exhale. Slowly bend the elbows and lower the body while maintaining a straight body as close to the floor as you can, without touching the floor. Straighten both the legs, reaching back through the inner heels and the inner balls of both the feet. Hold this position for three to four breaths and then lower the body down and relax.

# ADHO MUKHA SHAVASANA (DOWNWARD DOG POSE)

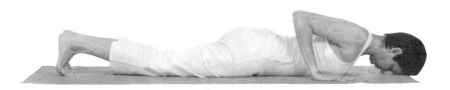

- Lie down on the floor on your abdomen, face downwards. Keep your feet about an inch apart with the toes curled. Rest your palms by the side of your chest with fingers straight out towards your head.

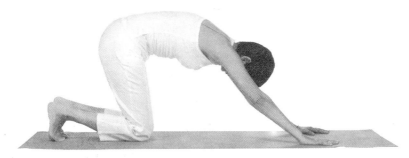

- Exhale. Raise your hips while lowering your head between your arms. Bend the knees.

94

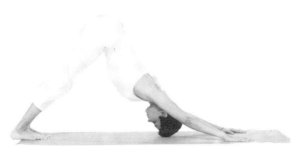

- Left the body up, forming a triangle with your back and legs. Keep the legs stiff, and without bending your knees, try to press the heels and the soles of your feet on the floor. Try to bring your head towards your knees, press on the plams and lengthen the spine. Stay in this position for 30 to 40 seconds, breathing deeply.

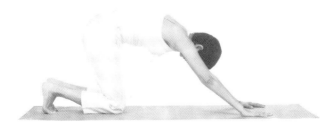

- Release the posture by touching the knees on the floor, stretching the torso forward and lowering your body gently down to the floor.

95

# SIRSASANA (HEAD STAND)

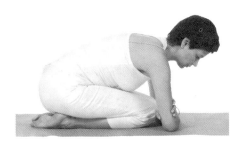

- Sit up on the ankles; place each hand on the opposite elbow, measuring the distance between them. Bring the arms to the floor under the shoulders.

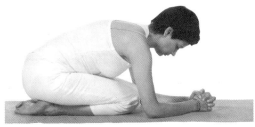

- Without moving the elbows, bring the hands together so that the arms form a tripod on the floor; interlock the fingers, and open the palms.

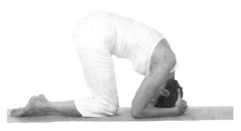

- Place the frontal portion of the top of the head (crown of the head) on the floor with the back of the head against the clasped hands.

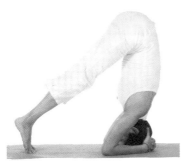

- Without moving the elbows and the head, straighten the knees, lifting the hips. Start to walk with the feet forward, trying to keep the knees straight. Keep walking until the hips are directly over the head. Practice this position for a few days before proceeding further.

97

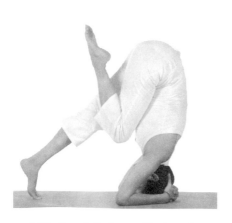 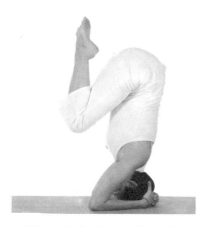

- Lift the left leg off the floor, keeping the knee towards the chest. Hold this position for a few seconds. Now lower the left leg down and repeat the same with the right leg. Practise this for a few days.

- Lift both the legs off the floor, bending the knees into the chest. Make sure the spine maintains its natural curve.

- Keeping the knees bent together, slowly straighten the hips until the bent knees are pointing to the sky, pushing the elbows on the floor.

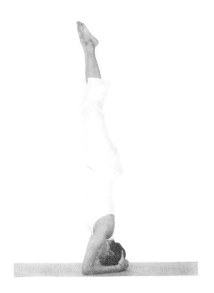

- Slowly straighten the knees, bring the feet up, the toes flexed out and the elbows firmly fixed on the floor. Hold this position for a few seconds, breathing deeply. Release the headstand by reversing the procedure of going up. Bend the knees and hips to bring the feet on the floor and place the hips on the ankles. Touch the forehead on the floor and relax in this position.

# Setubandh Sarvangasana (One-legged Bridge Pose)

- Lie flat on the floor with the legs together, arms by your sides and palms facing the floor. Bend the knees and keep the feet slightly wider than hip-distance apart and hold the ankles with both hands. Inhale. Tuck in the tailbone and lift the hips as high as possile to bring the spine off the floor. Hold this position for a few seconds.

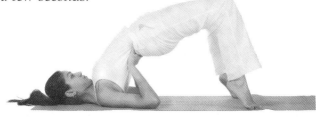

- Come on the toes and bend the elbows to support the spine with the palms. Squeeze the shoulder blades together and lift the chest towards the base of the neck  to place the ankles down. Hold this position for a few seconds, breathing deeply.

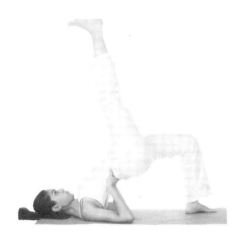

- Inhale. Lift the right leg and extend the foot towards the ceiling. Hold this position for a few seconds. Exhale. Bring the right leg on the floor and repeat the same with the left leg.

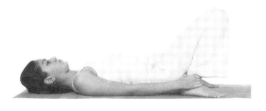

- Exhale. Bring the hips down and relax.

101

# Sarvangasana (Shoulder Stand)

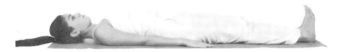

- Lie flat on the floor with the legs together, arms by your sides with palms facing the floor.

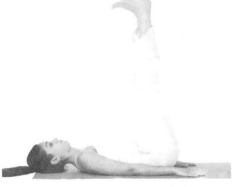

- Inhale. Raise both the legs until they are at right angles to your body. Then, slowly raise them even further by gently lifting your hips and back from the floor. Support yourself by pressing your palms on the floor.

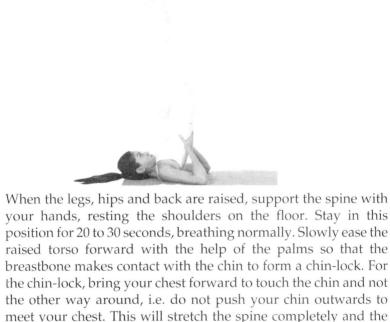

- When the legs, hips and back are raised, support the spine with your hands, resting the shoulders on the floor. Stay in this position for 20 to 30 seconds, breathing normally. Slowly ease the raised torso forward with the help of the palms so that the breastbone makes contact with the chin to form a chin-lock. For the chin-lock, bring your chest forward to touch the chin and not the other way around, i.e. do not push your chin outwards to meet your chest. This will stretch the spine completely and the full benefit from the *asana* will be derived. To release the posture, drop the legs towards the forehead at a 45-degree angle to your body. Place the palms flat on the floor and slowly bring your legs down.

103

# HALASANA (PLOUGH)

This *asana* is a continuation of *sarvangasana*.

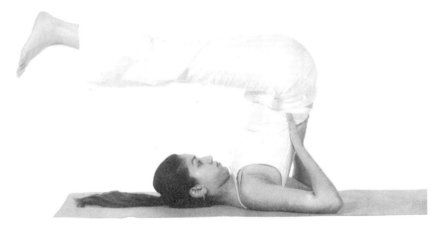

- Gently bring both legs down towards the back of your head, keeping the back supported with the palms throughout. Touch the toes on the ground behind the head, transferring the weight to your toes. Straighten the legs by keeping the knees straight. Make sure that the toes are turned inward towards the head. Keep the heels pointing up. Contract the hip and abdominal muscles.

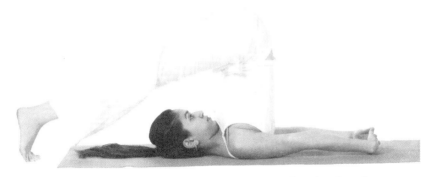

- If the toes are firmly supporting your weight, slowly release your arms which were supporting the back and place them flat on the floor and parallel to each other. Hold the posture for a few seconds. To release the posture, come back up into the *sarvangasana* and slowly bring your body to its original position.

# Matsyasana (Fish Pose)

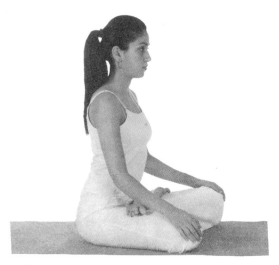

- Sit with your legs in front. Bend the right leg and place the foot on top of the left thigh, sole facing upward and the heel close to the pubis bone. Bend the left leg and place the foot on top of the right thigh with the sole facing upwards and the heel close to the pubis bone. Straighten the spine and make sure the knees touch the floor (if they do not, place a cushion under the knees). Relax the arms and place them on the thighs, palms opening towards the sky. Focus on the breath and relax the body.

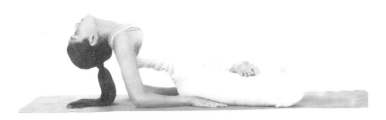

- Inhale. Bend backwards, supporting the body with the elbows and the arms.

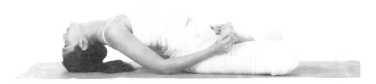

- Exhale. Arch the spine by lifting the neck and the chest. Take the head back and rest the crown of the head on the floor, holding the big toes with the arms and rest the elbows on the floor. Try and get the maximum arch in the spine. Relax the arms and let the head, hips and the legs support the weight of the body. Breathe deeply and hold this position for 20 seconds. Inhale. Release the big toes, place the palms on the floor and lift the head up and return to the starting position.

107

# 10

# Pranayama

The process of breathing is automatic, spontaneous and natural. We breathe constantly, even when we are unaware of it. Breathing provides the body and all our organs with oxygen, which is vital for our survival. Oxygen also rids the body of toxins. A good intake of oxygen makes a person lively and full of energy. It so happens that most people breathe incorrectly.

Not knowing the correct manner of breathing implies usage of only a small portion of the total lung capacity. This type of 'shallow breathing' deprives the body of the right quantity of oxygen required for the body's health and results in toxic build-up. This in turn lowers resistance to disease. Proper, concentrated breathing helps to reduce tension and stress. There are times when unknowingly we take a deep breath while thinking of something that concerns us, because this does ease and relieve stress. The importance of breathing with full awareness is clearly evident.

Yoga helps to bring the focus to the breath, thereby ensuring expansion in usage of lung capacity and relaxation of the nervous system.

In yoga postures, the freedom of breath is the first priority. One must always learn to keep the awareness on the breath. If you are a beginner, start with simple movements, as this will allow you to focus your attention on the breath and not on the movements of the muscular-skeletal system. Start by focusing on the breath — the way it moves into the body and out of the body; the basic inhalation and exhalation. As you begin your practice of yoga postures, you must gradually allow your body to move with the rise and fall of the breath. Let the internal body – the joints, muscles and organs — move as the breath expands and contracts. This will improve the quality of your *asanas* gradually. Other essential points to bear in mind while in a posture are enumerated below:

• Learn to control the exhalation and not the inhalation. Energy is renewed with the release of breath and not by pumping the lungs full of air. Exhaling helps the body to accommodate itself to change. Therefore, change of breath can totally change how each posture feels. Also it is the best way to ensure that all the focus is on the *asana*.

• Lengthen the exhalation. Make the exhalation longer than the inhalation as this will induce relaxation. Not only will this soothe the mind but will also help in lengthening the muscles, making the body supple and flexible.

• Lengthen both the inhalation and exhalation to give depth to the postures. Keep the inhalation and exhalation equal to stabilise the attention and to focus. Finally, extend the length of the pauses between each inhalation and exhalation to deepen the effect of the breath and the postures.

110

• Knowing how important breathing is in yoga, always include in your practice two important forms of *pranayama*: the *nadi shodhana* and the *ujjayi pranayama*. Start by focusing your awareness on the focal point of the breath — the way it moves into the body and out of the body, i.e. basic inhalation and exhalation. The *ujjayi pranayama* is done very carefully by producing a gentle sound from the throat by narrowing the flow of breath in the throat. This requires lots of practice before you can master it. Then incorporate the *ujjayi* breathing with the regular *asana* practice. This makes the mind more alert during the *asana* practice, as the mind is occupied with the sound and the flow of breath, and secondly, the sound made during the *asana* tells us when we need to stop holding the posture, to rest and move into the next postures. *Nadi shodhana* is done with the proper breath ratio. Begin by 2:8:4 and then slowly increase the breath ratio. An important point to keep in mind while practicing this breath is that retention of breath has to be comfortable.

Let us look at a few ways to breathe while in a posture.

# NADI SHODHANA (ALTERNATE NOSTRIL BREATHING)

- Sit in a comfortable cross-legged position. Relax your entire body and keep your eyes closed. Allow your breath to become calm and rhythmic.
- Bend your right arm at the elbow. Fold your middle and index fingers inwards to your palm. Bring your ring finger and the little finger towards your thumb.
- Place your right thumb on the right nostril and your ring and little fingers on the left nostril. By pressing your thumb, block your right nostril.

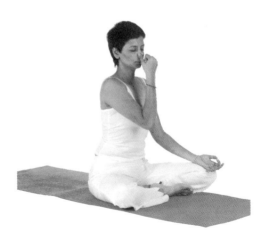

- Inhale slowly and deeply through your left nostril to the count of 4. After a full inhalation, block your left nostril with your ring and little fingers and retain your breath to the count of 16.
- Exhale, releasing the pressure from your right nostril. Release the air slowly, deeply and steadily to the count of 8.
- Now inhale deeply from your right nostril, blocking the left nostril to the count of 4. After a full inhalation, retain the breath for 16 counts.
- Block your right nostril. Exhale slowly, deeply and steadily for 8 counts from the left nostril.
- This completes one round. Try to do 10 to 12 rounds.
- Lie down in *shavasana* and relax.

# UJJAYI PRANAYAMA

- Sit in a comfortable position with eyes closed. Relax your body. Allow your breath to become calm and rhythmic.

- Inhale deeply from both nostrils through the throat, keeping your glottis partially closed in order to produce a sound of low uniform pitch (*sa*).

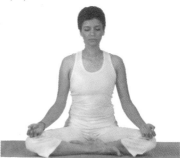

- Fill your lungs, but do not to bloat your stomach. Exhale slowly and deeply until your lungs are empty. As you exhale, the air should be felt on the roof of the palate and should produce a sound (*ha*). These sounds should be so silent that only you should be able to hear.

- This completes the first sequence. Wait for a few seconds to begin the next round.

- Repeat 10 to 15 times.

# Relaxation

Relaxation provides relief and diversion from work for the mind and the body. The state of the mind and the state of the body are intimately linked. Yoga makes us aware of the body and thus enables us to consciously control tension and relaxation. In today's world, we are bombarded with stimuli that leave us in a state of mental and physical tension. This tension drains our energy and is the major cause of tiredness and ill health. Relaxation releases muscular tension, infusing the body with calmness. To relax is to rejuvenate. To rejuvenate is the key to good health, vitality and peace of mind.

To work on relaxing the body one must first experience tension. Enumerated below are the steps to first building tension and finally relaxing and rejuvenating the body:

- Lift your right foot just an inch off the floor. Make the leg tense and then let it drop.
- Repeat on the other side.
- Raise your right hand an inch off the floor. Clench you hand into a fist, make the arm tense and then let it drop.

- Repeat on the other side. Relax.
- Clench your buttocks tightly together, lift the hips a little off the floor and hold. Relax and drop them down.
- Lift up the back and chest, keeping your hips and head on the floor. Relax and drop them down.

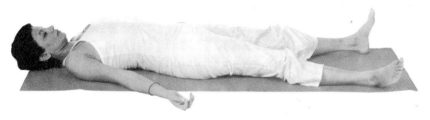

- Lift your shoulders and hunch them up tight around your neck, then let them drop.
- Now pull each arm, in turns, down alongside the body and relax.
- Tuck in your chin slightly and roll the head gently from side to side. Find a comfortable position in the centre for the head to lie down and relax.
- Now let your mind travel throughout the body, commanding each part to relax. Let yourself go. Sink deep into the quiet pool of the mind.

116

After practicing this sequence, visualise your body in your mind's eye and repeat this simple formula mentally: "I relax the toes, I relax the toes. The toes are relaxed. I relax the calves, I relax the calves. The calves are relaxed." Continue by moving upwards and applying the formula to each part of the body — the stomach, lungs, heart, jaw, scalp, brain, and so on. Feel a wave of relaxation rise up your body as you guide your awareness through each part. Each time you inhale, feel a wave of oxygen flowing down to your feet; each time you exhale, feel the tension flowing out of your body, leaving your mind like a deep, still lake, without a ripple. Now dive deep into the centre of this lake, deep within yourself, and experience your true nature. To bring your consciousness back to your body, gently move your fingers and toes take a deep breath. Finally exhale and sit up.

# Developing Home Practices

Even if we were to attend a regular yoga class at a centre near our residence, it is very important to devote time to home practice. Achieving this is a challenging task as it requires commitment, time and perseverance. Enlisted below are tips and suggestions from my experience as a yoga instructor. They helped me develop my own home practice.

## Motivation

- Yoga has taught me to live my life with awareness and to live in the present moment. It has taught me to be a better person and each time I ended the class, I was overwhelmed with a deep sense of gratitude for all that I have in my life. This motivated me to work towards it at home. Similarly, you need to find your own motivation for yoga. The motivation will come from deep within, so listen to your inner voice, as it is motivation that gets you started.

- Enthusiasm has to be developed for you to begin your daily yoga

119

practice. Incorporate the element of fun in your practice. Put on some light music you like to listen to and then practice. Keep your yoga practice interesting by performing *asanas* with an attitude of inquisitiveness and playfulness.

- Invest in a mat that does not shift; it is the only equipment needed for your daily practice. Find a small place in any part of the house that will enable enough movement for your practice.

- Work on finding the balance and steadiness in your practice. Stay alert throughout the session and keep a clear head. Design the session according to the time available and concentrate on creating equilibrium. Leave the difficult postures for the yoga class.

- Feel your breath throughout the day. Your breath is a stress releaser. Take breaks to close your eyes while focusing on the breath. Learn to carry this breath with you when you step on your yoga mat to begin a session.

- Keep a diary to note all the challenges that you face while doing a posture. This will enable you to meet these challenges in your next class. Also, instead of mastering the *asana*, notice the effect of the posture on the mind. Write down all that you feel while in a posture. This will reveal your own self and help you pick up currents of your present emotional state.

- Educate yourself. Read inspiring and yoga related-books to get more information on the subject. This will keep you motivated and help you in changing your outlook.

- Try to lead a disciplined life. This is difficult but with steady effort, it is possible to achieve.
- Remember that the time you spend on yoga is the time you devote to yourself. It is special to you, and for no reason should you miss the practice. If you do miss your practice for one reason or another, learn to feel guilty about it as *yoga is serious business.*

# 13

# Diet for Strength and Flexibility

Food is the fuel that keeps the body healthy and supple. Food is the essential input that energises and revitalises the body, keeping it alive for 80 years, the average life of a human. Thus, it is very important to pay attention to what we eat. The principle of nutrition is to eat small quantities of high quality food. In yoga, simple food that promotes health, vigour and vitality, i.e. the life force, is recommended as these foods do not produce toxins. Rich food causes toxins to get accumulated in the muscles, causing stiffness and inflexibility. Therefore, diet plays an active role in developing strength and flexibility of the body.

The main reason for the body to get stiff is calcification in the body. Calcification is the deposit of insoluble salts in the soft tissues of the body. This primarily occurs under conditions of inactivity and poor dietary habits, resulting in shortening of smooth muscles, decrease in blood flow and blocking of energy from passing through. Another reason for tightening and stiffness is age. As we age, our body does not produce the essential antioxidants. It is important for those who practice yoga to maintain a balanced diet. Diet plays a vital role in the

making of our mind and body, and yoga is the most systematic system that helps us identify ourselves with what we eat.

A proper yogic diet is *sattvic* or pure vegetarian. According to yogic philosophy, meat being animal flesh has a low vibration rate and tends to lower the life of the person. Meat also contains toxins, especially lactic acid — a waste product of muscle metabolism, and also contains fat, cholesterol and other substances that are toxic. This reduces vitality and slows down progress in yoga. But every individual has his own taste and this book does not ask you to stop eating non-vegetarian food. What it does recommend is a balanced diet.

Include in your diet a wide variety of fruits and vegetables as they fill the body with life-giving minerals, vitamins and fibre that are an important source of energy. Fruits are especially nutritious and can be eaten raw. It is important to note that in yoga, unprocessed food is highly recommended. This is because once processed, the food loses a lot of its vital vitamins and minerals. This implies that one should rely more on fresh fruits and vegetables than on frozen or canned food and that the greater proportion of our food should be eaten raw, for example, fruits, salads, raw nuts and sprouted grains. The same principle applies to sugar. Sugar, especially processed sugar, has no nutritional value and it only produces toxins in the body. One should switch to natural sweeteners that are unprocessed, such as honey, raw cane sugar and jaggery.

Another dietary rule in yoga is that the temperature of the food should be neither too cold nor too hot. This is because either of the two extremes can harm the tissues of the throat and destroy the taste.

Moreover, one should eat slowly. Chewing food helps increase the alkalinity of the food, thereby making it easier to digest. If food is eaten slowly and if the digestive system is in order, one can extract the right nutrients from food as well as eliminate toxins with proper yogic exercises

Thus, the food recommended in yoga is the food that promotes vitality and is an important source of nutrients and minerals. Grains are good for you, especially whole grains that are a rich source of fibre, and dairy and milk products and protein-based foods such as pulses and beans. Vegetables like lettuce, cabbage, capsicum, broccoli, carrots, beetroot, pumpkin, cucumber, corn and sweet potato are a must. In case of fat, yoga is assertive that the joints of the body need lubrication and so one should take about 20 per cent of fat in the diet.

The final habit one should imbibe is the cleansing of the body through adoption of the system of Ayurveda. In the modern-day world, we are constantly subjecting our body to the build up of toxins. We live our lives without awareness. In Sanskrit, 'toxin' in our body is referred to as *ama*, meaning 'undigested residue'. It clogs the body, creating sickness both internally and externally. Our bodies are designed to retain what is useful and eliminate what is not and cleaning the body is a step in this direction. The main channels of elimination are the colon, the lungs, the bladder, the kidneys. The skin, supported by a good lymph system, helps in their functioning. Eating the right food, changing our lifestyle, drinking lots of water, practicing yoga postures and breathing exercises regularly and fasting once or twice a week will assist the body in its endeavour to cleanse. Adherence to these rules

will keep us fit for life and will increase the overall strength from within.

By replacing negative thoughts with positive ones, yoga replaces self-judgment and shame with true appreciation and pleasure in a healthy body. Yoga teaches us to love our body. So explore each posture, the space in between the *asanas* and the breath that moves deep within. Sense each and every movement you make with the body and try to live your life with the same awareness and in the same loving and healthy way.

# 14

# Yoga – A New Beginning

Yoga is a commitment we make to ourself; we root our entire being in it. The end of this book should be the beginning of our yogic journey to attain strength and flexibility. And this strength and flexibility should extend beyond the realms of the physical. The yogic techniques, the *asanas*, the *pranayama* and then relaxation will connect us through our body to our mind. We will focus only on the present and establish harmony with our true being.

Yoga is a pause or time-out from the hurried and rushed pace of life. Over time, it makes us realise that there is more to life than the race in the pursuit of worldly aims. This will make us calm and composed; we become one with Nature. The body in turn will be ever energised and rejuvenated to experience life the way it should be experienced— happily, fearlessly. The result: a mind and spirit that is calm and noble and a person confident in his physical being, exuding strength and character.